CW00969308

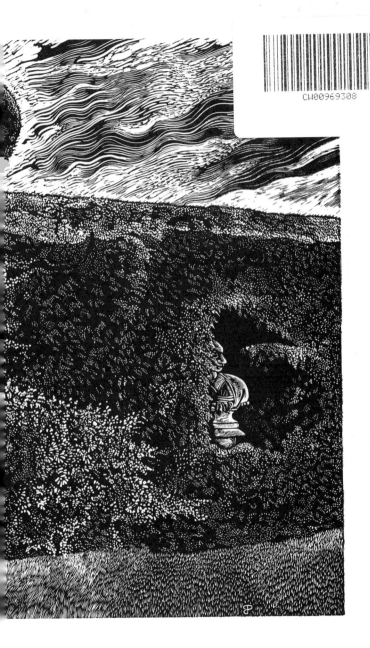

To Dear Rhonda,
Who sees the
beauty that
others pass by
love from
Colin '03

ENGRAVED GARDENS

ENGRAVED GARDENS

CORDELIA JONES
MIRIAM MACGREGOR
BETTY PENNELL
YVONNE SKARGON

SILENT BOOKS

CAMBRIDGE

First published in Great Britain 1989
by Silent Books, Swavesey, Cambridge CB4 5RA

ISBN 1 85183 016 2

Typeset by Goodfellow & Egan
Printed in Great Britain by
St Edmundsbury Press, Bury St Edmunds, Suffolk

All engravings are reproduced actual size.

WE ARE fortunate that the garden at Gravetye, in Sussex, which was Robinson's old home, still retains the character which he imparted to it. I am able to vouch for this continuity, for I first visited the garden during the first world war. At this time William Robinson was a pioneer in allowing the public to view his garden. There was nothing then so demeaning as an entrance fee, you went to the front door and the butler presented you with the visitor's book to sign, and the garden was yours. My second visit was during the 20s and on this occasion I was privileged to meet William Robinson. He was then an old man in a wheel chair and he had caused the main flower border to be raised on a low retaining wall so that he could more easily see the plants and pull the occasional weed, from his wheel chair. But, despite his age, he gave short shrift to a gardener who looked sceptical as Robinson planned future improvements, saying "You think I won't live to see it, just you wait." My most recent visit was a few years ago when I was delighted to find the garden much as I first remember it and in charge of it was a very sympathetic head gardener.

The two features which impressed me most on my early visits were the flowery meadows stretching down the slope from the terrace wall, and the water-side of the lakes at the bottom of the valley. The meadow garden has become a popular feature in many of today's gardens but in the early

years of the century it was a novelty. I remember well, on my childhood visits, how enchanted I was by the miniature hayfield, be-jewelled with small tulip species, many kinds of anemones and many other flowers not then usually seen in gardens. It was, however, an intensification of the meadows of those happy days before the advent of hygienic agriculture, which were a child's paradise rich in buttercups and daisies, cowslips, orchids, milkweed and speedwell. The terrace wall backing this meadow was festooned with swags of purple aubrietia. I hope it still is.

Perhaps Robinson's passion may be summed up in this quotation. "Of all things made by man for his pleasure, a flower garden has least business to be ugly, barren or stereotyped, because in it we may have the fairest of the earth's children in a living, ever-changeful state, and not, as in other arts, mere representation of them."

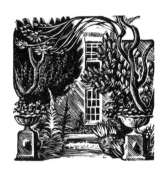

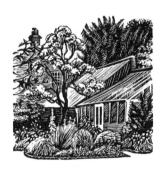

CRASTER HOUSE

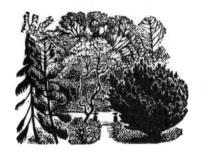

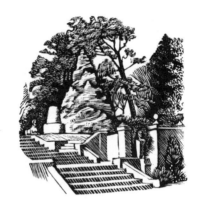

CRASTER HOUSE

BLICKLING HALL

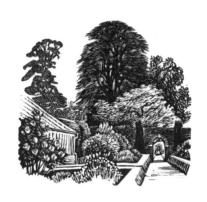

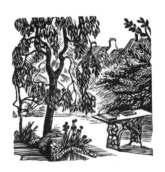

FELBRIGG HALL

EARLHAM ROAD

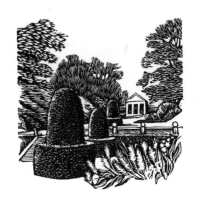

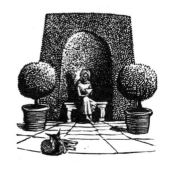

BLICKLING HALL

WALSINGHAM

BRENT ELEIGH HALL

FELBRIGG HALL

THARSTON MILL

BLICKLING HALL

FELBRIGG HALL

COLD ASTON

BURGH HOUSE

TO THOSE who live in the Antipodes a European Christmas is synonymous with snow and skating parties, perky robins and roaring log fires, roasted chestnuts, mulled wines and all that goes with icy mid-winter in the northern hemisphere.

December in the southern hemisphere is totally different. My brief is to tell you of my personal pleasure ground, to weave you a chaplet of sweet summer buds and steep you in the essence of my mid-summer Christmas at a time when activity in the northern garden is at its lowest ebb.

As you sit in your firelit rooms enjoying the rarefied scents from a nearby glass of winter flowers (have you noticed how the fragrance released from winter aconites, *Eranthis hyemalis*, in a warm room exactly approximates that of sweet peas?) I am drowning my senses in the sights and sounds, niffs and whiffs, colours and textures of the mid-summer pomps of my December garden.

While you contemplate a favourite book or turn the pages of an old botanical tome, or perhaps watch for the slow unfurling of your stylosa iris buds, I am sampling the parallel pleasure of the more rapid unfolding of my moonflowers, the parasol buds of which tremble into bloom with the suddenness of time-lapse photography.

Like all winter-bound gardeners you are no doubt scheming and dreaming for the seasons to come and building

horticultural castles in the air. Here in your dream the sweet succession of the seasons will lay ever more delights and floral treasures at your feet. While you so dream, let me whisk you south in imagination to the land of the long white cloud, Ao-tea-roa, a land where gardening dreams often do come true.

Right now it is summer, three days past the summer solstice, Christmas Day.

Christmas is an especially busy time for the southern hemisphere gardener. Not only must the traditional rites be observed but it is also the season of summer holidays and one of the most demanding periods in the garden. In particular must the garden's constant cry for water be met; not an easy task in many towns where summer hosing restrictions have to be rigorously enforced. Many have their own artesian wells, a happy solution where such water is available. Watering container plants twice a day is not too much in hot summers. Beverley Nichols once remarked when visiting our country that the amount of summer watering necessary was the only factor deterring him from wanting to live here, in what was otherwise a gardener's paradise.

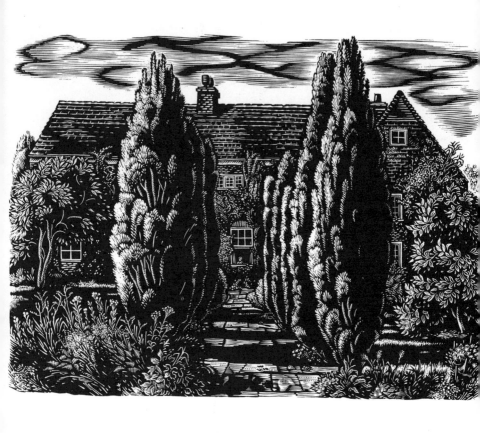

INGRAMS FARM; NINEFIELD

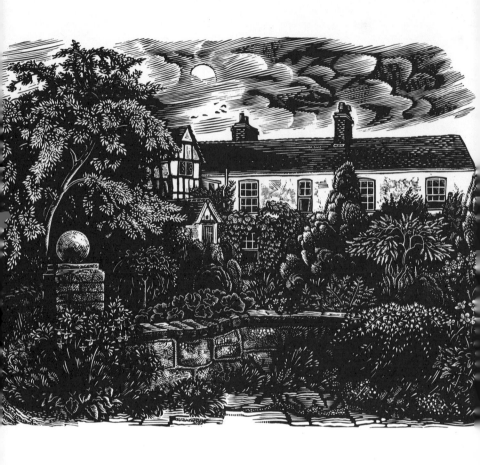

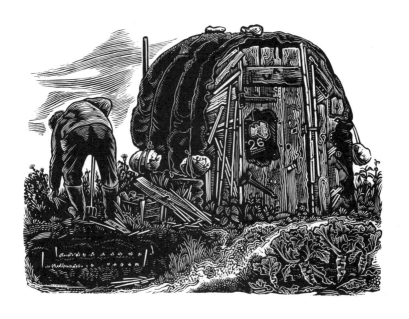

SHED NO. 26

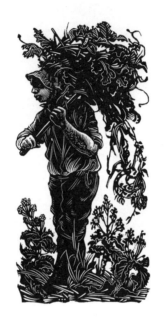

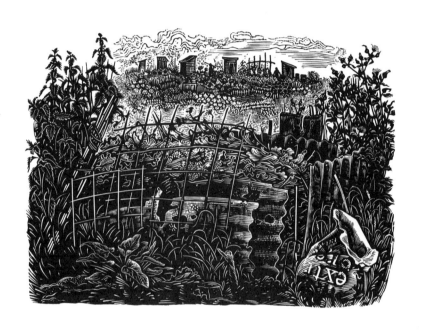

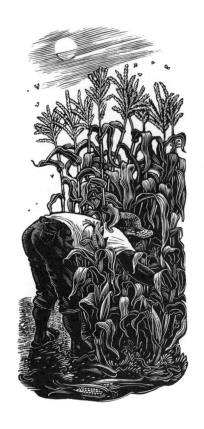

OF ALL the ingredients we employ in the creation of a garden, scent is probably the most potent and the least understood. Its effects can either be direct or immediate, drowning our senses in a surge of sugary vapour, or they can be subtle and delayed, slowly wafting into our consciousness, stirring our emotions and colouring our thoughts. Sometimes a scent will linger in the air for days, filtering through open windows and engulfing armchairs and dinner tables; at other times a fragrance will evaporate almost the moment it arrives, leaving only a tantalising taste in the nostrils. Plants themselves play tricks with their scents, exuding perfume one day and not the next, chemically altering their fragrance from sweetness to putrefaction.

Faced with all this uncertainty and unpredictability, gardeners tend to shy away from any attempt to manage scent in the garden in any coherent way. Fragrance becomes very much an afterthought, an addition to a carefully composed planting scheme. Only after deciding that your border should consist of silver foliage and yellow flowers, for example, and after organising a pleasing arrangement of tiered heights and contrasting leaf forms, will you stop for a moment to consider whether you have incorporated any items to please your nose. To a large extent this sort of approach to planting is inevitable. This visual impact is after all crucial. But I wonder whether you have ever thought of attempting the process in

reverse in one or two parts of the garden and taken up the challenge of allowing scent to dictate the entire composition.

The best place to construct a scented scheme is somewhere sunny and sheltered, ideally against a warm wall where the air is still and where heat is radiated on cool evenings, somewhere you are inclined to sit and ruminate, where you will be most receptive to a fragrant siege. A seat is a most important component for, apart from encouraging relaxation, it enables you to enjoy many different scents simultaneously. Not only can you position aromatic foliage around your feet, scented perennials at your elbow and fragrant shrubs near your nose, but you can construct the seat out of scent as well by making a raised bed of chamomile and prostrate thymes and giving it arms and a back rest.

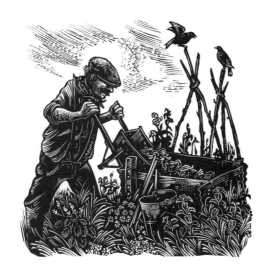

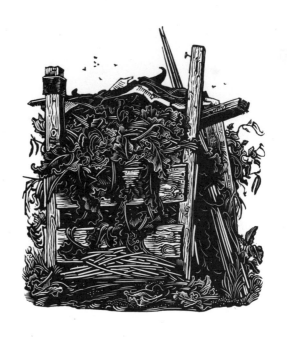

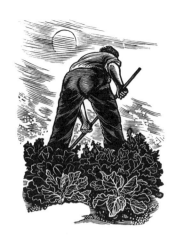

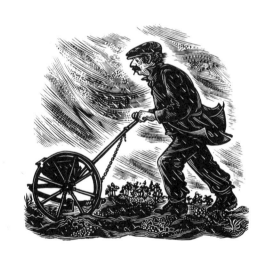

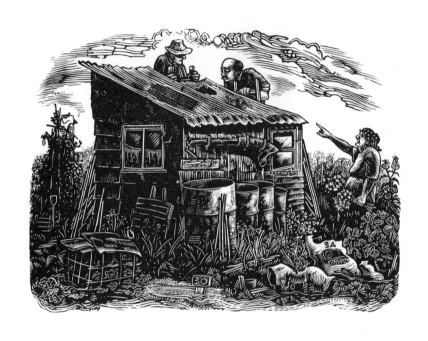

SHED NO. 30

LOOKING round gardens, how many of them lack that quality which adds an extra sensory dimension for the sake of orderliness? There is an antiseptic tidiness which characterises a well-controlled gardener. And I'd go further and say that usually the gardener is male. Men seem more obsessed with order in the garden than women. They are preoccupied with flower bed edges cut with the precision of a pre-war hair cut. Using a lethal curved blade, they chop along the grass to make it conform to their schoolboy set squares, and with a dustpan and brush they collect 1 cm of wanton grass. Or, once they hold a hedge-trimmer, within seconds they have guillotined all those tender little growths on hawthorn or honeysuckle hedges that add to the blurring and enchantment of a garden in early June.

The very soul of a garden is shrivelled by zealous regimentation. Off with their heads go the ferns, ladies' mantles or crane's bill. A mania for neatness, a lust for conformity and away goes atmosphere and sensuality. What is left? Earth between plants; the dreaded tedium of clumps of colour with earth between. So the garden is reduced to merely a place of plants. Step – one, two. Step – one, two; look down (no need ever to look up for there is no mystery ahead to draw you on), look down at each plant. Individually each is sublime undoubtedly. For a plantsman this is heaven. But where is lure? And where, alas, is seduction and gooseflesh on the arms?

There is a place for precision, naturally. Architectural lines such as those from hedges, walls, paths or topiary are the bones of a garden. But it is the artist who then allows for dishevelment and abandonment to evolve. People say gardening is the one occupation over which they have control. Fine. But why over-indulge? Control is vital for the original design and form; and a ruthless strength of mind is essential when you have planted some hideous thing you lack the courage to demolish. But there is a point when your steadying hand should be lifted and a bit of native vitality can be allowed to take over.

One of the small delights of gardening, undramatic but recurring, is when phlox or columbines seed themselves in unplanned places. When trickles of creeping jenny soften stony outlines or Welsh poppies cram a corner with their brilliant cadmium yellow alongside the deep blue spires of Jacob's ladder all arbitrarily seeding themselves like coloured smells about the place.

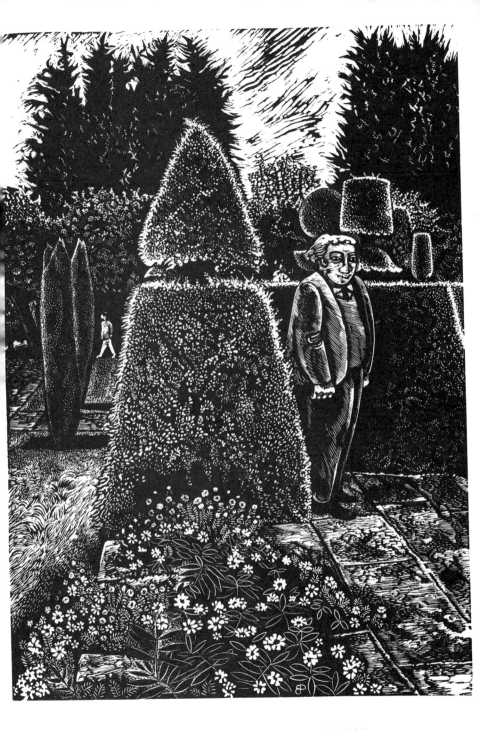

IN A COUNTRY GARDEN; RODMARTEN MANOR

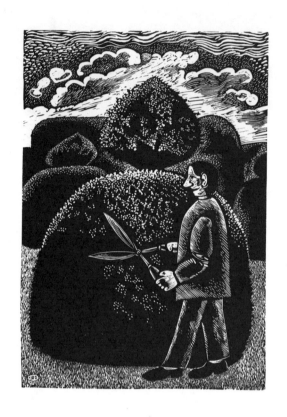

CUTTING TOPIARY; LYTES CAREY

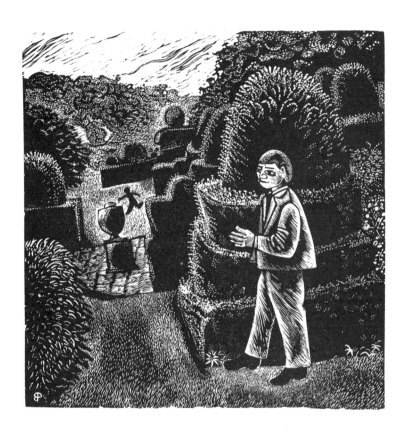

RUNNING AWAY; MAPPERTON MANOR

ONE OF the incidental pleasures of reading E. F. Benson's Mapp and Lucia novels is in the way someone is always doing a little gardening. Gardens play a part in many novels. What would Blandings Castle be without the superb backdrop of its stately garden? Where would Lord Emsworth potter, when, having gazed and gazed again at his beloved sow The Empress of Blandings, unless among his roses? In the garden is peace of a kind. Within the castle disturbers of his lordly peace lurk, his deplorable sister and his equally distressing secretary the efficient Baxter. But the peace of Lord Emsworth's gardens is disrupted. A hurled potted geranium has been known, shrewdly aimed, to find its mark. In P. G. Wodehouse the garden is always possibly about to turn into an arena. Not so in Benson.

Benson's gardens are essentially safe, even cosy places. Daisy Quantock calls across her garden to Georgie Pillson in his as he is rolling his lawn. What should she do about slugs, she wants to know. The answer is good news indeed for slugs for he advises her to pretend she hasn't seen them. Gardening is a mysterious calling. Benson understood this. Mrs Quantock has dismissed her gardener for smoking his pipe in the potting shed while on duty. She sets to work with a will. She weeds with locust blind enthusiasm. Not a weed, soon, is in sight. On the other hand the carefully planted out annuals are quite gone too. Satisfied that she has done a good job, Daisy

gets in a slight muddle and plants the phlox in the vegetable garden and plants the broccoli close to the house. A true gardener, after a spell for reflection in the shed, would not make such a mistake. Benson cleverly tells us a great deal about Daisy Quantock obliquely.

In *Miss Mapp*, a dangerous but widely smiling woman is smarting. Her new rich neighbour Mrs Poppit has put up her glasses and inspected Miss Mapp's roses, her "friendship border". Each rose, you see, has been donated by a friend. Mrs Poppit detects a lack of vigour and tells her so. She offers to send round a few vigorous bushes. No lady of spirit could accept such an offer. Now Mrs Poppit has suffered much from the hand of Miss Mapp. The offer of roses and the suggestion that she should plant some fuchsias are actually rather like a sniper's bullet.

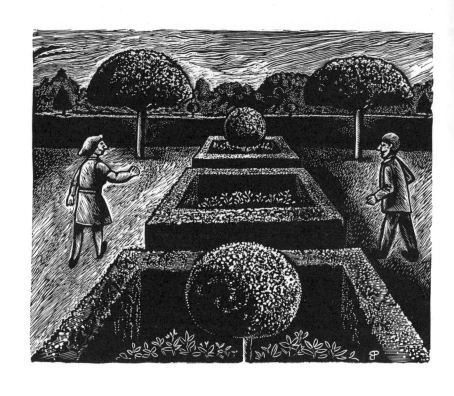

MEETING; WESTBURY COURT

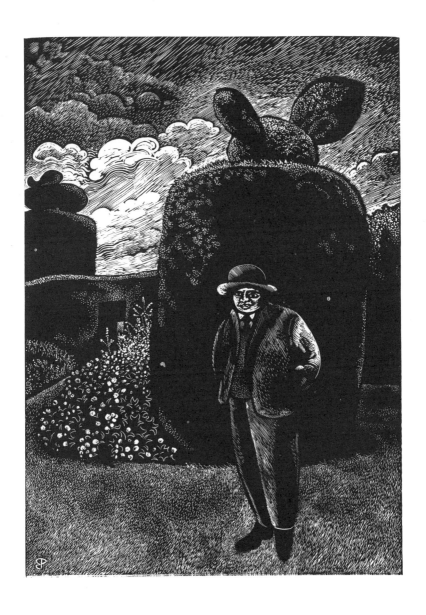

GARDENER; WIGHTWICK MANOR

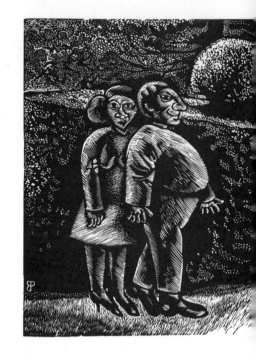

EVENING WALK; HERGEST CROFT

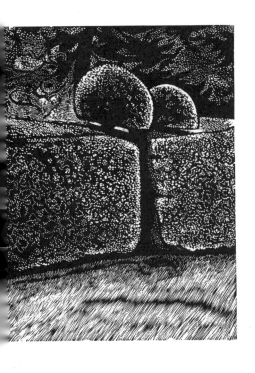

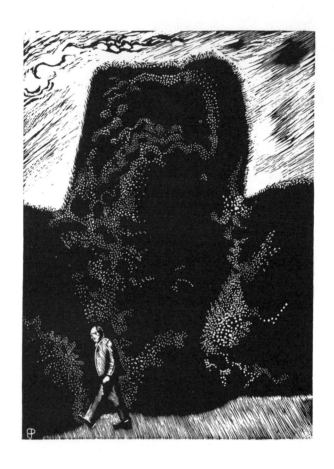

TALL HEDGE; PACKWOOD HOUSE

IN MY garden grows a plant called "Mrs Mills". She's a delightful semi-double pale pink dianthus with a very good scent. But you wouldn't recognise her as Mrs Mills, and nor would anyone else, so don't rush for your catalogues in puzzled pursuit. Once, long ago, Mrs Mills lived not far from us, and one day my father admired a very pretty plant in her garden. Cuttings were exchanged then and there. Both he and the lady are long since gone, but *Dianthus* "Mrs Mills" flourishes still. She has travelled the length of the British Isles, been lost to me, as I thought, and found again in my brother's garden whence she returned to my cottage garden where she seems to be very much at home.

Near "Mrs Mills" you will find "Ruby's Balm", a shade lover, with small pink flowers and deliciously sweet/sharp scented leaves. I never knew Ruby, but the kind friends who gave me the plant knew her well, and so in a first-cousin-once-removed sort of way she is my friend too. Anyway, who is going to talk of *Calamintha grandiflora* when they could just say "Ruby's Balm"?

What pleasure we derive from the associations marked by the pet names we give our plants. Sometimes it may be the association of place, rather than people. I once met the most miniscule erinus called "Berkeley Castle". The little flower was grown from seed filched from the massive walls of that imposing pile, but the name was not exactly descriptive!

It is clear that there can be pitfalls in the system for those not "in the know". What response can be made to the command, "Go and water Auntie Rita, she's gone all limp".

One of the gentle amusements afforded by the gardening world is that enjoyed by a third party witnessing a name-dropping contest by two evenly matched protagonists. The keen alpinists, especially, are favourites in these stakes. Points are scored for correct pronunciation as well as successful cultivation. Try saying "Androsace" in suitably throw-away style as in, "Has your *Androsace helvetica* done anything yet? That one I collected from the Bindelweg is looking very good."

"Super. Do come over soon to see my *Dionysia aretioides*. I'm hoping for seed from it next year."

At these rarefied heights labelling is part of the game too. For some, trimly lettered, prominently placed labels are a sight too unspeakably vulgar, betraying a less than perfect instant recall of all the treasures in the collection. For others, the lack of them bespeaks a carelessness over accuracy and detail most reprehensible. Most of us, of course, take the middle way, labelling the newest acquisitions or at least marking the hidden bulbs which are in danger from an energetically wielded fork. We hope (a) that we shall find an indelible pen which actually means just that, (b) that the label will stay put despite the efforts of birds, dogs, children and enquiring visitors, and (c) that the plant will survive the label, rather than vice versa. How sad, those carefully inscribed names found after a hard winter, or onslaught by well-meaning but unskilled helpers, which mark only the grave of the once cherished plant.

The good old friends, however, have no need of labels, for their faces are familiar companions to our garden labours. If the lady had known the exact name of her pink, and my father

had been a more punctilious labeller I should now be able to recommend to you with precision a named variety of dianthus from the catalogues. But then I should not have the happy reminder of them which my pretty dianthus represents. I must go and take this year's cuttings of "Mrs Mills" and next week I shall go and see how Mary's Little Pink Rose is doing despite the threatening weigela.

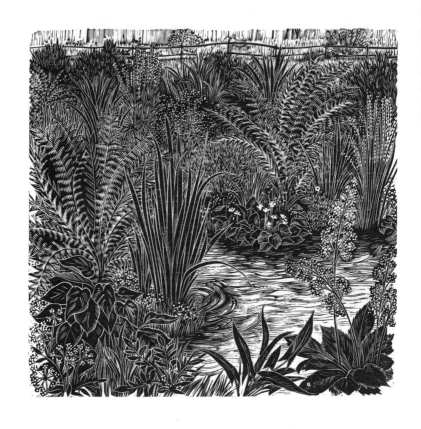

BOXFORD

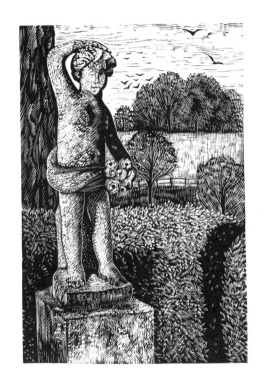

BUSCOT

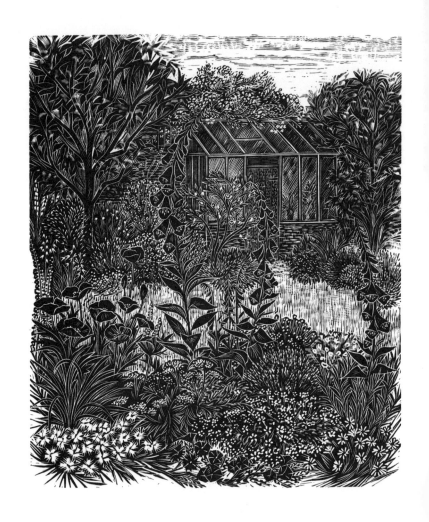

LAVENHAM

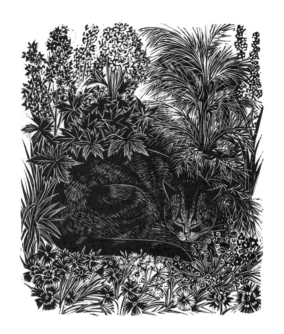

LAVENHAM

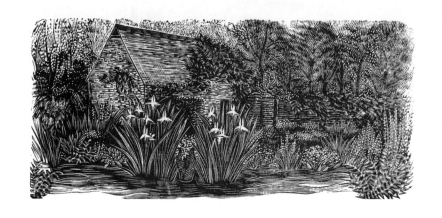

CLEE ST. MARGARET

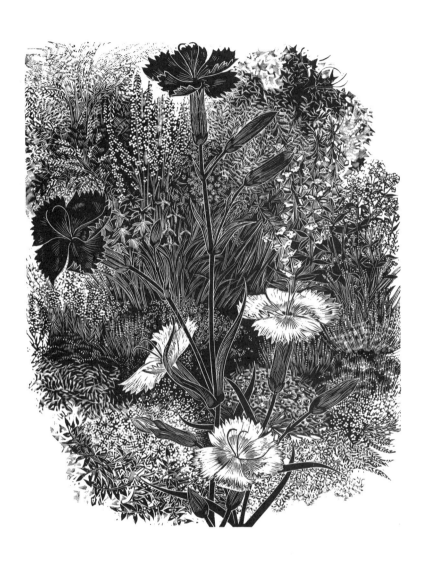

LAVENHAM

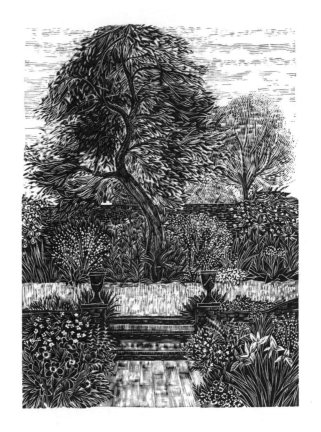

BOXFORD

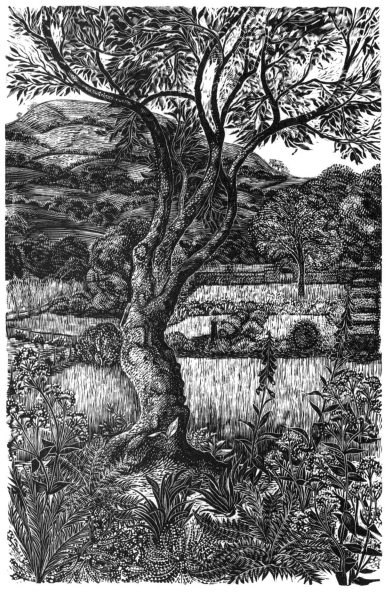

RHAYADER

CORDELIA JONES, b. 1936, discovered engraving through contact with Patricia Jaffé at Cambridge. As a writer of books for older children, it appealed to her as the perfect complement to type; the first book she illustrated was her own *A Cat Called Camouflage* (1970). Dissatisfied with the printing of the engravings, she bought a press in 1977 and began to produce cards, letterheads and other ephemera. In 1984 she exhibited in *The Artist at Work*, at Norwich, and in 1986 illustrated two books for the Japanese publishers, Iwanami Shoten.

MIRIAM MACGREGOR, b. 1935, worked for the publishers B. T. Batsford for several years in their Art Department and subsequently freelance. In 1977 she joined the Whittington Press, where she still works as a part-time compositor, and for whom she has illustrated a distinguished and delightful sequence of books, as well as others for other fine presses or publishers for whom Whittington prints. No one taught her to engrave: Stanley Lawrence gave her a demonstration over the counter, she says.

BETTY PENNELL, b. 1930, was at the Royal College from 1949 to 1952 and learned engraving from John Nash and Edward Bawden. From 1959 to 1964 she taught at Birmingham College of Art and since then has had her own studio as a painter and engraver in Herefordshire. As a painter, she uses engraving as an alternative means to express her feeling for English gardens and the countryside. She began engraving on wood and metal but now works on plastics of various kinds.

YVONNE SKARGON, b. 1931, works mainly as a book illustrator. Watercolours, drawings and wood-engravings, often on botanical and culinary themes, have been commissioned by many leading English publishers. For many years she worked as a typographer and book designer and for five years taught wood-engraving at the Royal College. She herself studied wood-engraving with Blair Hughes-Stanton and John O'Connor at Colchester. She now lives mainly in Suffolk where her botanical and naturalist interests find expression both in her work and in gardening.

The text in this book is extracted from articles which have appeared in *Hortus*, a privately published journal concerned with the decorative aspects of gardens: design and ornament, plants, people and books. Each quarterly issue elegantly presents the best of current writing about gardening and contains specially commissioned work by contemporary wood-engravers and illustrators. *Hortus* is available on subscription; details from *Hortus*, The Neuadd, Rhayader, Powys LD6 5HH, Wales.

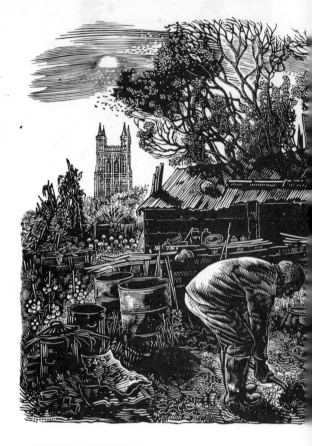

AUTUMN AFTERNOON